Doodled
DOGS

 GEMMA CORRELL

Brimming with creative inspiration, how-to projects, and useful information to enrich your everyday life, Quarto Knows is a favorite destination for those pursuing their interests and passions. Visit our site and dig deeper with our books into your area of interest: Quarto Creates, Quarto Cooks, Quarto Homes, Quarto Lives, Quarto Drives, Quarto Explores, Quarto Gifts, or Quarto Kids.

First Published in 2015 by Walter Foster Publishing, an imprint of The Quarto Group.
6 Orchard Road, Suite 100, Lake Forest, CA 92630, USA.
T (949) 380-7510 F (949) 380-7575 www.QuartoKnows.com

Walter Foster Publishing titles are also available at discount for retail, wholesale, promotional, and bulk purchase. For details, contact the Special Sales Manager by email at specialsales@quarto.com or by mail at The Quarto Group, Attn: Special Sales Manager, 401 Second Avenue North, Suite 310, Minneapolis, MN 55401 USA.

ISBN: 978-1-63322-656-2

Illustrated and written by Gemma Correll
Select text by Stephanie Carbajal

Printed in China
10 9 8 7 6 5 4 3 2 1

Table of Contents

How to Use This Book

This book is just a guide. Each artist has his or her own style. Using your imagination will make the drawings more unique and special! The fun of doodling comes from not trying too hard. So don't worry about making mistakes or trying to achieve perfection.

Here are some tips to help you get the most of this doodling book.

DOODLE PROMPTS

The prompts in this book are designed to get your creative juices flowing—and your pen and pencil moving! Don't think too much about the prompts; just start drawing and see where your imagination takes you. There's no such thing as a mistake in doodling!

STEP-BY-STEP EXERCISES

Following the step-by-step exercises is fun and easy!
The red lines show you the next step.
The black lines are the steps you've already completed.

SUPPLIES

Doodling doesn't require any special tools or materials. You can draw with anything you like! Here are a few of my favorite drawing tools.

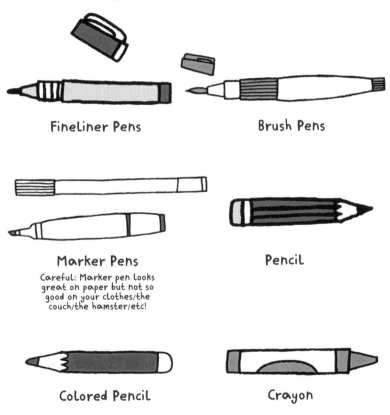

Fineliner Pens

Brush Pens

Marker Pens

Careful: Marker pen looks great on paper but not so good on your clothes/the couch/the hamster/etc!

Pencil

Colored Pencil

Crayon

6

Part 1

ALL
ABOUT
DOGS

DRAW OR PASTE A PICTURE OF YOUR DOG IN THE FRAME.

My Dog

Favorite Game:

Favorite place to sleep:

Favorite toy:

Favorite snack or treat:

Favorite way to be naughty:

20 Signs you're a DOG Person

1 You celebrate your dog's birthday.

2 Your phone is full of photos of your dog—
not your friends and loved ones.

3 You eat budget meals, while your dog dines like a prince.

4 You are perpetually covered in fur and drool.

5 You send holiday cards signed by you and your dog.

6 Your cookie jar is full of doggie biscuits.

7 Your favorite place to shop is the pet store.

8 You have separation anxiety when you're
away from your dog for even a few minutes.

9 You get jealous when your dog cuddles with somebody else.

10 Your pockets are full of poop pick-up bags.

11 You talk to your dog when nobody else is around.

12 Your dog's grooming costs more than your own haircut.

13 Your dog has his own website and Facebook page.

14 Your email address is dogperson@ilovedogs.com.

15 You learned to knit just so that you could make winter sweaters for your pooch.

16 Your social life (or lack thereof) revolves around your dog.

17 The couch and the chair are full of dogs. That's okay; you'll sit on the floor.

18 Your alarm clock is a wet nose to the forehead and three licks to the face.

19 Your doormat says, "Wipe your paws."

20 You haven't worn a pair of matching socks since Fido first came home.

A Day in the Life

Eating, sleeping, playing...not a care in the world! Our spoiled pups are truly livin' the life.

7:30 AM Lick Human's face repeatedly until Human gets out of bed

7:45 AM Once human is up, snuggle into their warm spot on the bed

8 AM Dog food—scatter a few pieces on the floor to save for later

10 AM Take Human on a walk— pee on every tree

11 AM Naptime

12 PM Terrorize the cat

1 PM Potty break—bark at all the squirrels

3 PM	Investigate the kitchen trash
4 PM	Naptime
5 PM	Play ball!
6 PM	Dinner and a belly rub
8 PM	Milk-bone treat
9 PM	Patrol the grounds on night watch
10 PM	Bedtime—feign sleep on dog bed
10:30 PM	Jump into Human's bed when the snoring starts—nighty-night!

Dog-toids

For many, dogs are a source of joy, entertainment, comfort, and laughs. Here are just a few reasons our canine cohorts are so special!

 Fact: There are more than a dozen separate muscles that control Fido's ear movements. No wonder they're so expressive!

Fact: Dogs are capable of hearing sounds at about four times the distance that humans can hear.

 Fact: The "smell" center of your pup's brain is 40 times larger than yours.

Fact: Your doggie's nose has a unique ridged pattern— like a human fingerprint!

Fact: Dogs have similar sleep patterns and brain activities as humans—next time you see your pooch twitching in her sleep, it probably means she's dreaming.

 Fact: Dogs only have sweat glands in their paws—the main way they cool down is by panting.

Fact: An average dog can run about 19 miles per hour at full speed.

 Fact: A wagging tail doesn't always mean a happy dog. Studies show that dogs wag their tails to the right when they are happy and to the left when they are sad.

 Fact: Puppies sleep for 90 percent of the day in their first few weeks of life!

Fact: The average body temperature for a dog is a warm 101.2 degrees Fahrenheit.

 Fact: Puppies have 28 teeth, and adult dogs have 42!

Dozens of Dogs

You don't need to have your own dog to be a dog person.
You can doodle any dog, any time, anywhere!

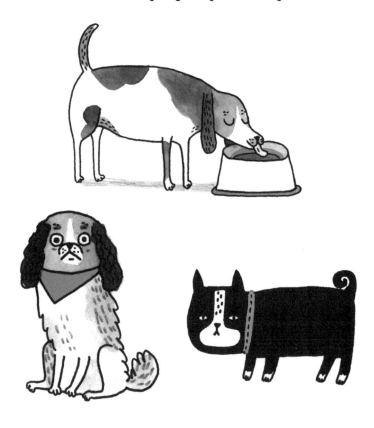

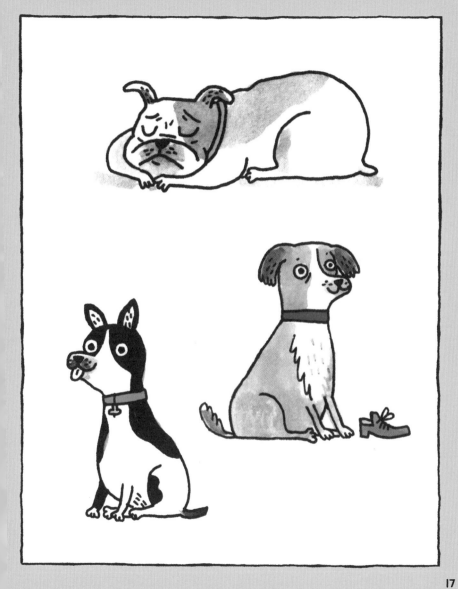

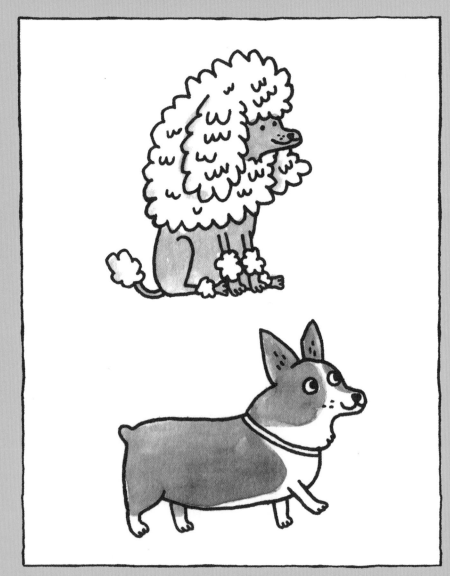

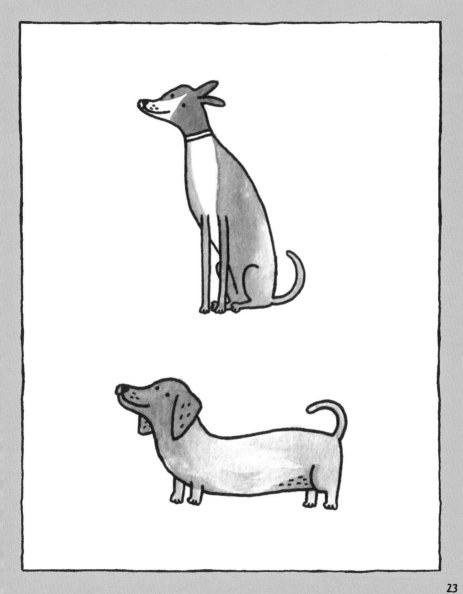

Doodled Dog Faces

Some dogs have long noses. Some have squishy noses.

Some dogs have really big eyes. Some have small eyes.

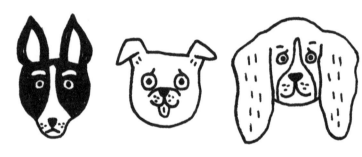

Some dogs have sticky-up ears. Others have floppy ears.

Some dogs have wide faces. Some have thin faces.

Some dogs look worried all the time
(even if they are smiling inside).

Some dogs have eyebrows that make them
look very serious.

Some dogs like to stick their tongues out a lot.

Some dogs are really good at looking pathetic
so that you'll give them treats...

Okay, so that's all dogs.

Dog-Spressions

Dogs show their feelings with their ears and faces.

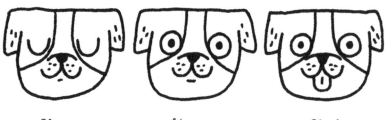

Sleepy Happy Cheeky

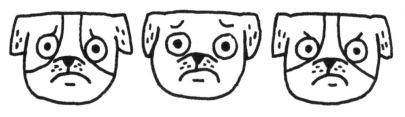

Worried Scared Annoyed

Suspicious

Thoughtful

Angry

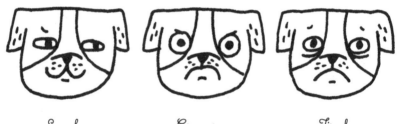

Sneaky Grumpy Tired

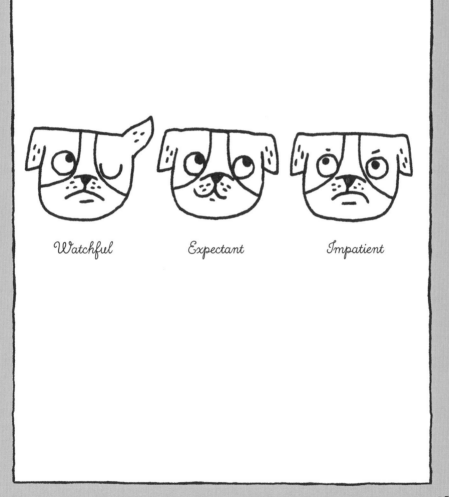

Watchful Expectant Impatient

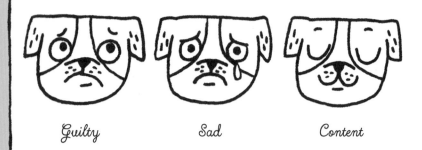

Guilty Sad Content

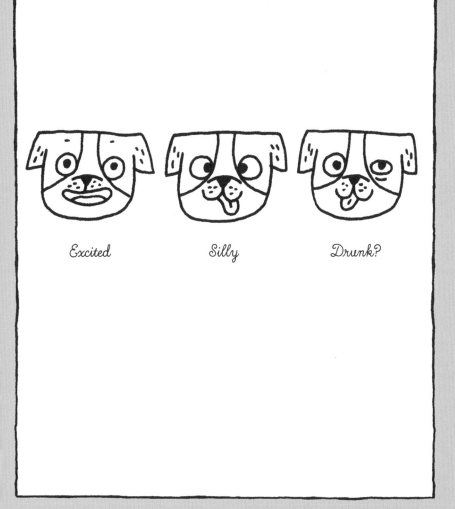

Excited Silly Drunk?

Doodled Dogs

Dogs come in all shapes and sizes—
From teeny-tiny chihuahuas and enormous great
danes to squishy-faced pugs and skinny whippets.

SMALL DOGS

Chihuahua

Pomeranian

Yorkshire Terrier

French Bulldog

Lhasa Apso

Pug

Miniature Pinscher

Dachshund

Bichon Frise

MEDIUM DOGS

English Bulldog

Beagle

Schnauzer

Pitbull

Basset Hound

Cocker Spaniel

LARGE DOGS

Greyhound

Boxer

Standard Poodle

Rough Collie

Afghan Hound

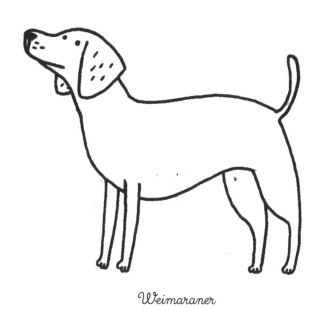

Weimaraner

DOGS from A to Z

Can you think of a dog breed for each letter of the alphabet? Some of the more challenging letters have been filled in to help you get started!

A. _____

B. _____

C. _____

D. _____

E. _____

F. _____

G. _____

H. Harrier

I. _____

J. Japanese Chin

K. _____

L. _____

M. _____

N.

O.

P.

Q.

R.

S.

T.

U. Utonagan

V. Vizsla

W.

X. Xoloitzcuintli

Y.

Z. Zuchon

What's in a Name

Stumped on what to name your next furry friend?
Check out these suggestions for inspiration. Then add
your own ideas to the List!

Mr. Darcy
This one's for all you
Literary mavens

Vuitton
For the fashion Lover

Admiral
For the dog who rules
the home

Anastrophe
Perfect for the grammar geek

Sir Ruffington III
For fancy dogs only

Target
Paying homage to your
favorite place to shop

Basil
After your favorite herb

Newcastle
Because what more do you
need on a Friday night?

Part 2

DOODLED DOGS STEP BY STEP

Draw a Funny French Bulldog

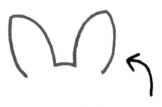

1. Start with the ears. Make them big!

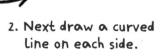

2. Next draw a curved line on each side.

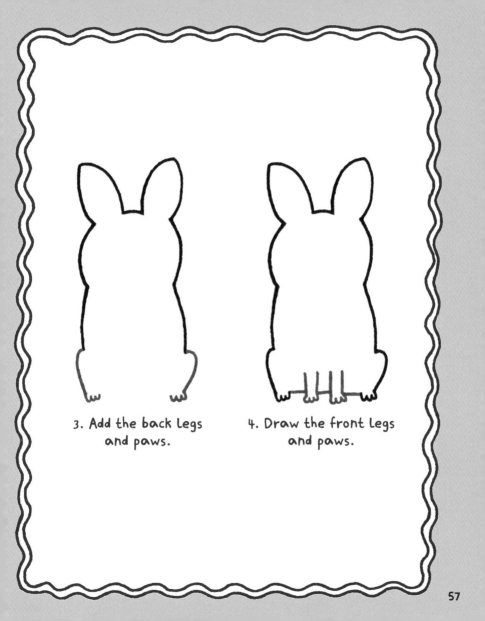

3. Add the back legs and paws.

4. Draw the front legs and paws.

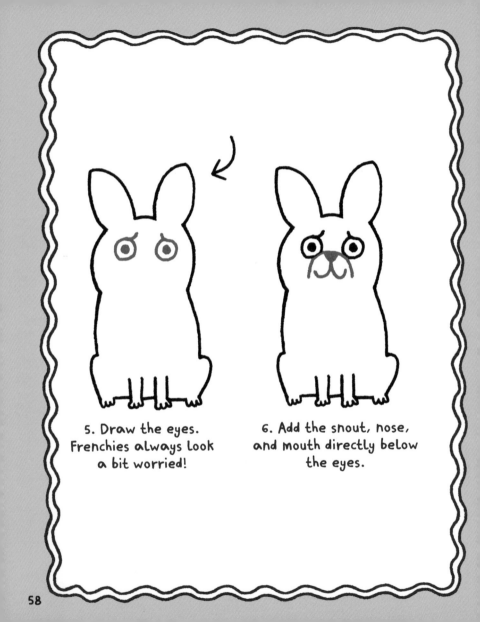

5. Draw the eyes. Frenchies always look a bit worried!

6. Add the snout, nose, and mouth directly below the eyes.

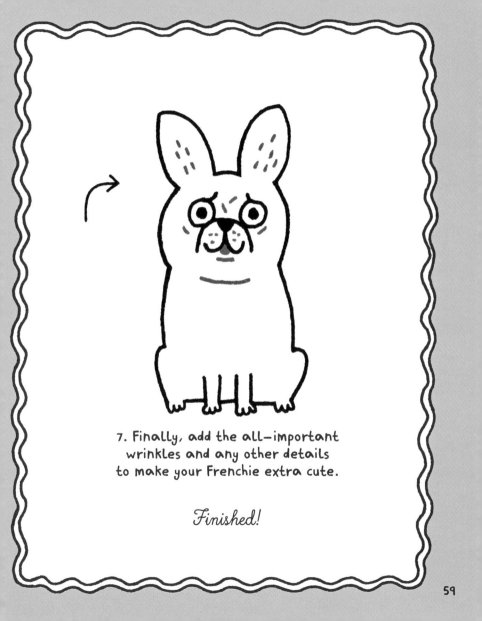

7. Finally, add the all-important
wrinkles and any other details
to make your Frenchie extra cute.

Finished!

Draw a
Dapper Dachshund

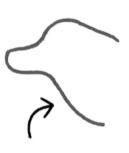

1. Draw this shape
 for the head.

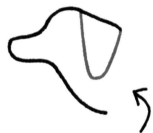

2. Add the ear.

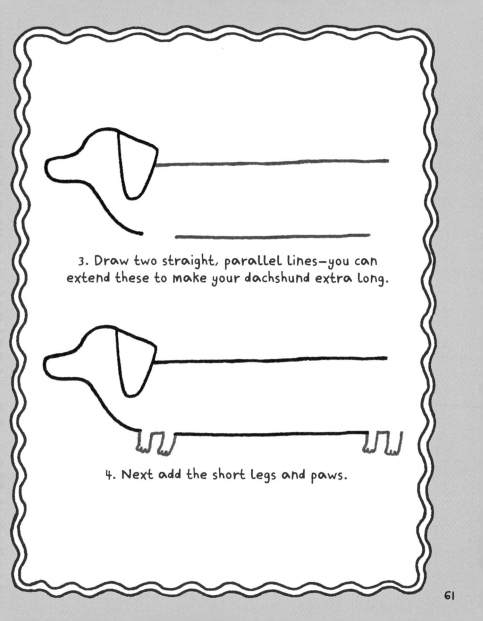

3. Draw two straight, parallel lines—you can extend these to make your dachshund extra long.

4. Next add the short legs and paws.

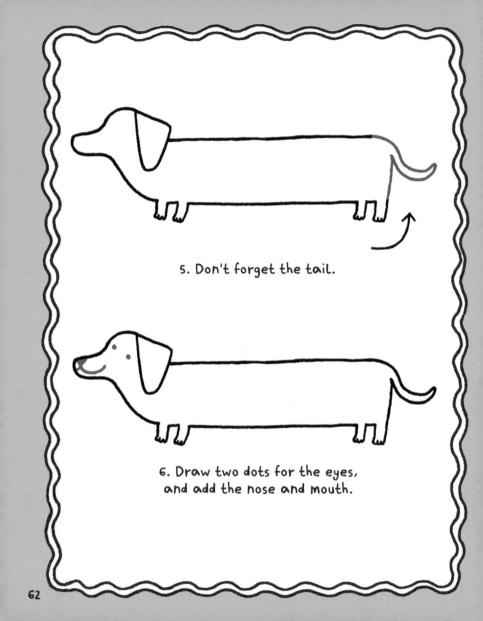

5. Don't forget the tail.

6. Draw two dots for the eyes,
and add the nose and mouth.

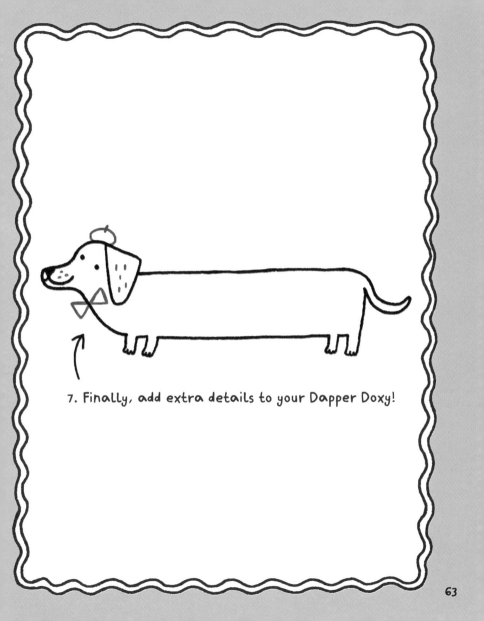

7. Finally, add extra details to your Dapper Doxy!

Draw a Bitchin' Bichon Frise

1. Draw a bubble for the head.

2. Add ears.

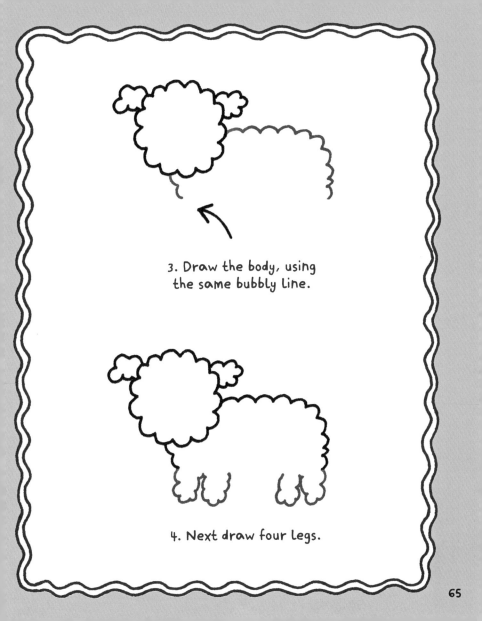

3. Draw the body, using the same bubbly line.

4. Next draw four legs.

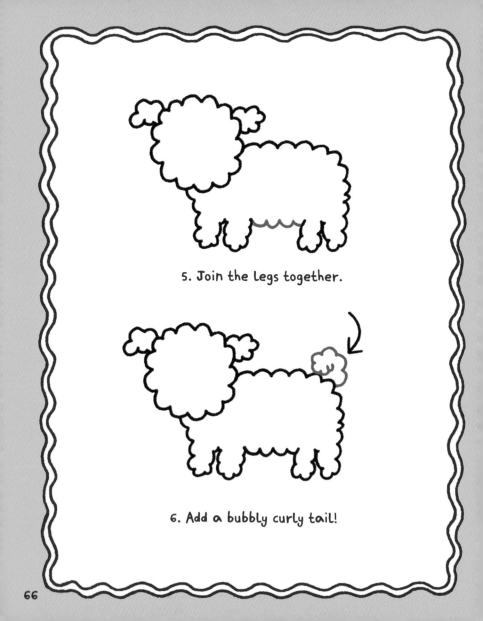

5. Join the legs together.

6. Add a bubbly curly tail!

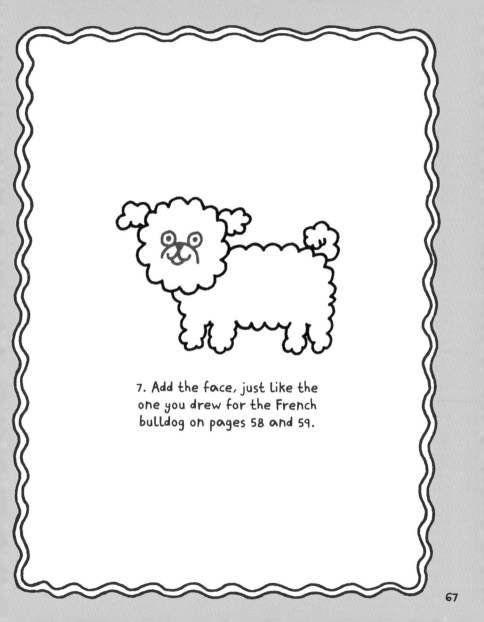

7. Add the face, just like the one you drew for the French bulldog on pages 58 and 59.

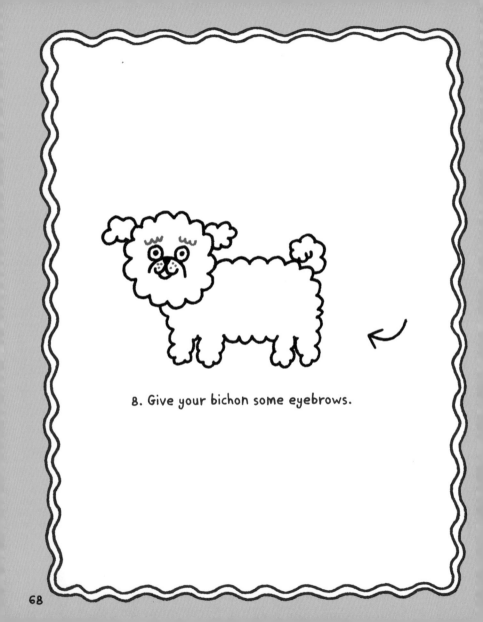

8. Give your bichon some eyebrows.

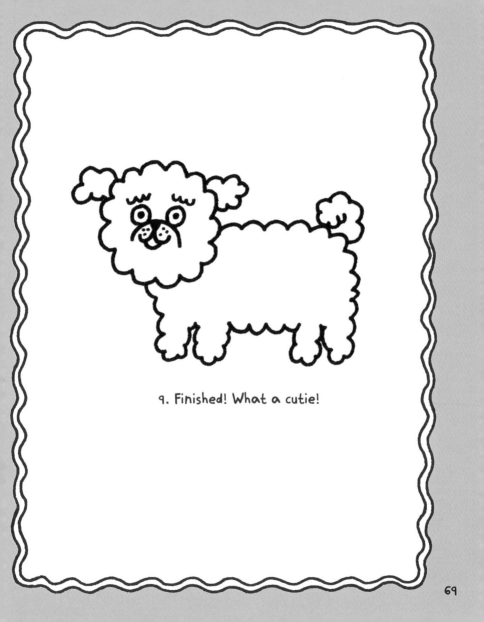

9. Finished! What a cutie!

Draw a Gorgeous Greyhound

1. First draw the head shape like this.

2. Add the collar.

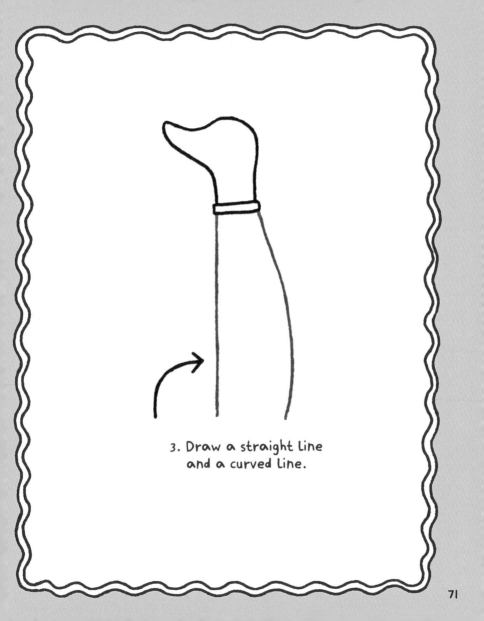

3. Draw a straight line
and a curved line.

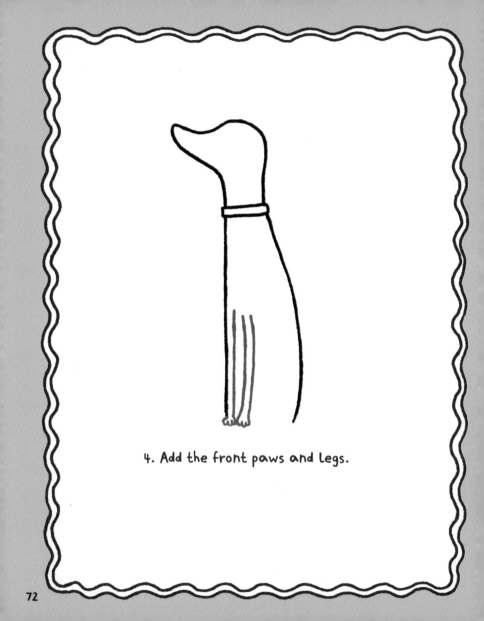

4. Add the front paws and legs.

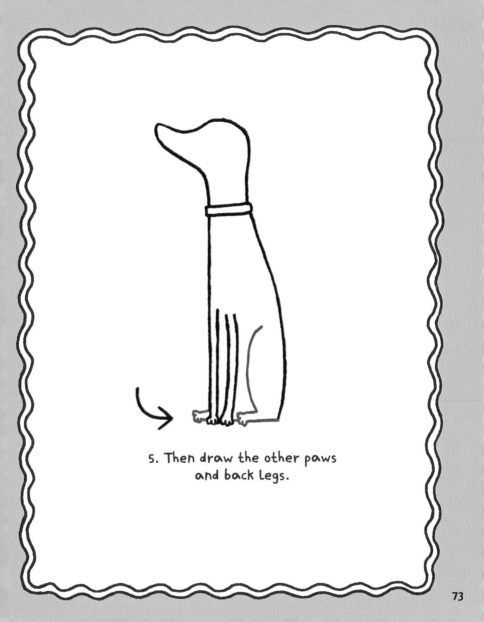

5. Then draw the other paws
and back legs.

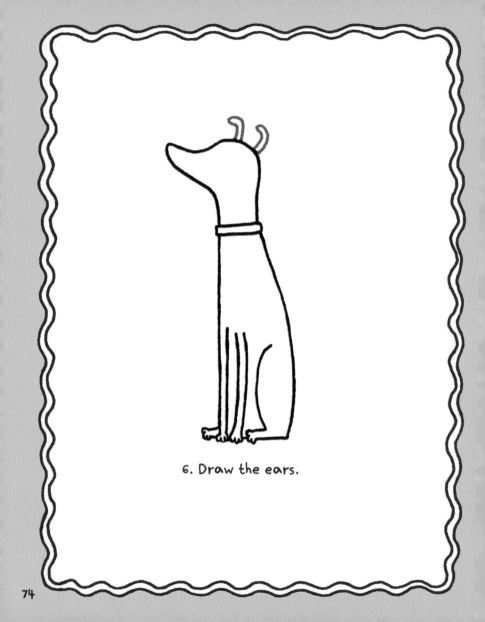

6. Draw the ears.

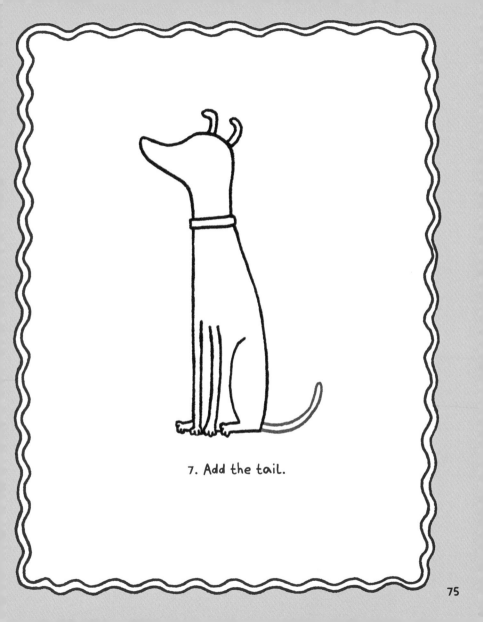

7. Add the tail.

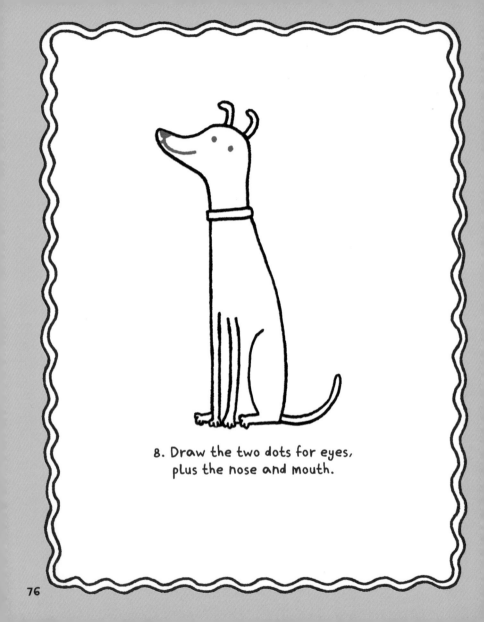

8. Draw the two dots for eyes,
plus the nose and mouth.

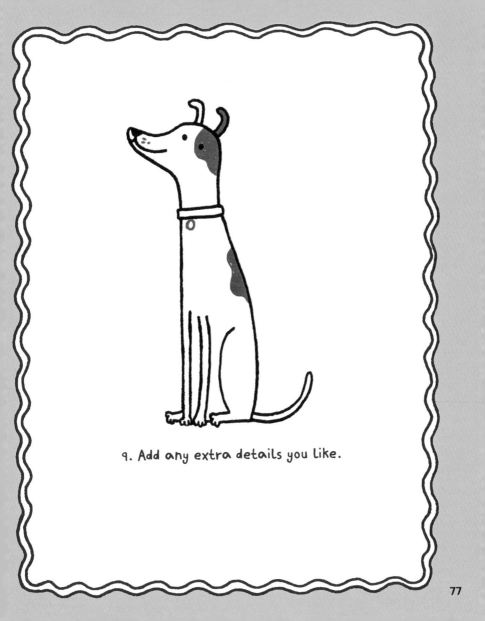

9. Add any extra details you like.

Draw a Cool Collie

1. Start by drawing this shape.

2. Add another ear.

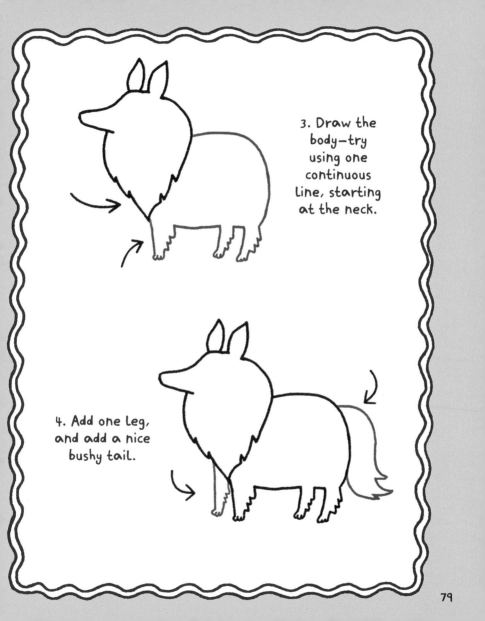

3. Draw the body—try using one continuous line, starting at the neck.

4. Add one leg, and add a nice bushy tail.

79

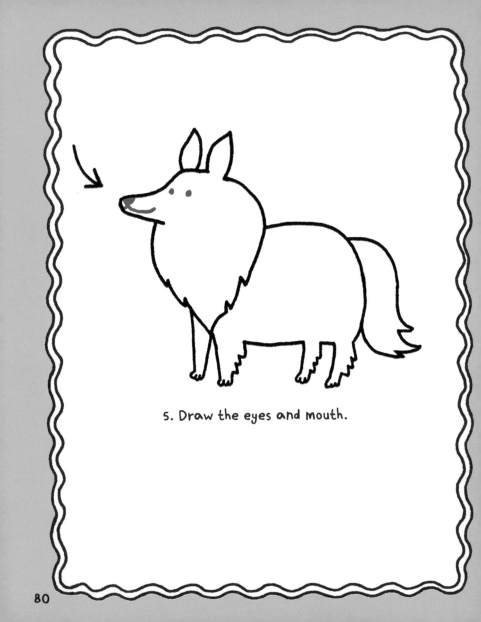

5. Draw the eyes and mouth.

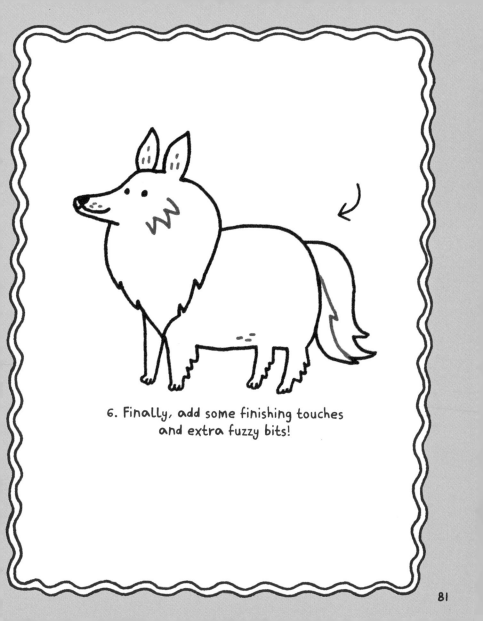

6. Finally, add some finishing touches
and extra fuzzy bits!

Draw a Perky Poodle

1. Start by drawing a fluffy blob!

2. Add this shape for the head.

3. More fluff.

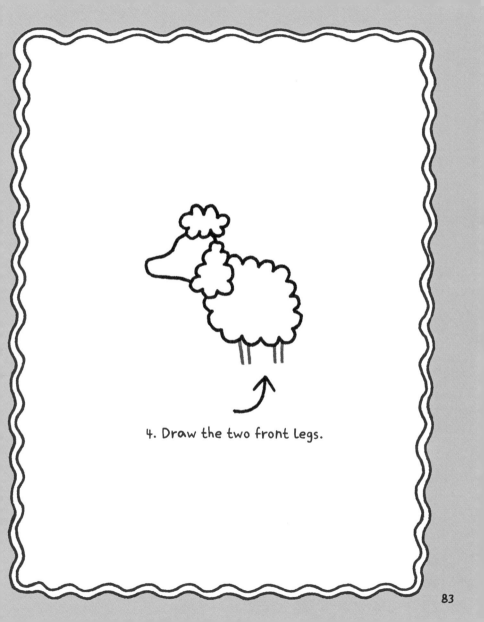

4. Draw the two front legs.

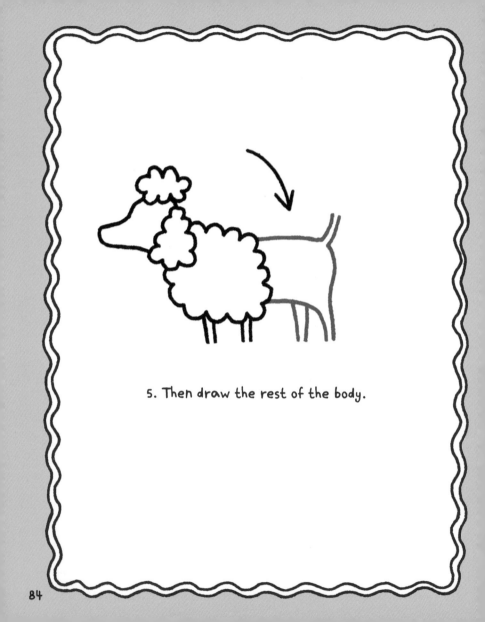

5. Then draw the rest of the body.

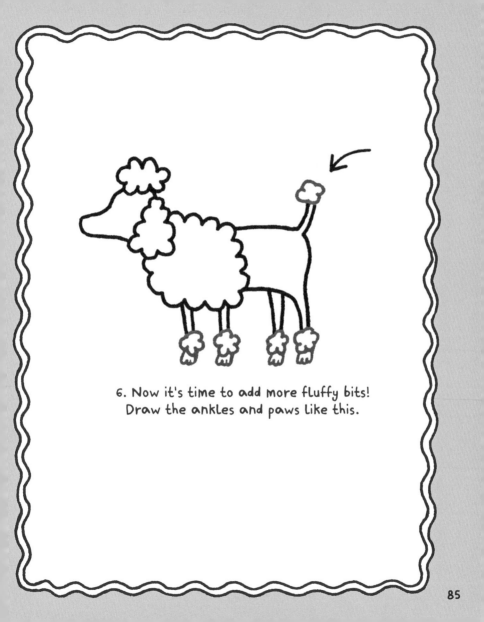

6. Now it's time to add more fluffy bits!
Draw the ankles and paws like this.

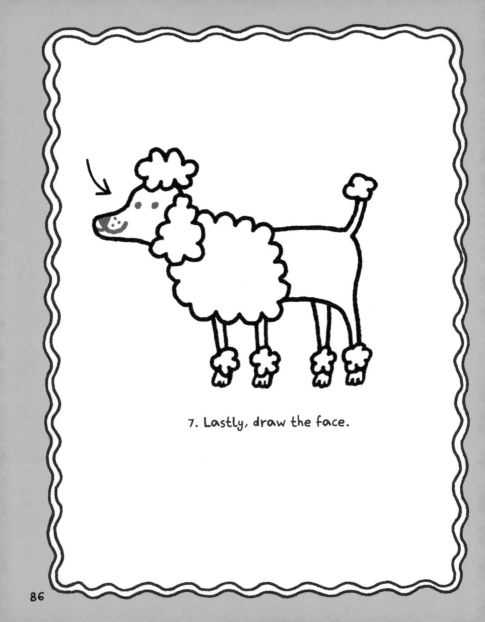

7. Lastly, draw the face.

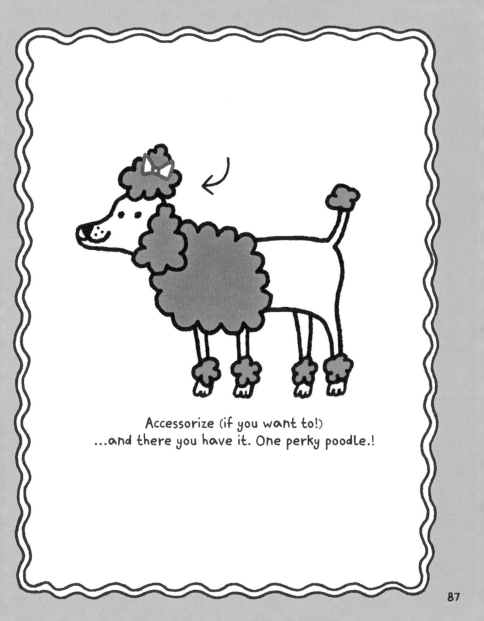

Accessorize (if you want to!)
...and there you have it. One perky poodle.!

Part 3

IT'S A DOG'S WORLD

Dogs in Hats

Fez

Sombrero

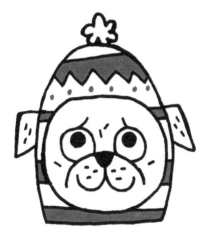

Woolly Hat

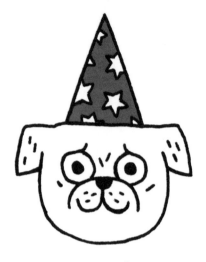

Wizard's Hat

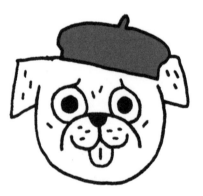

Beret

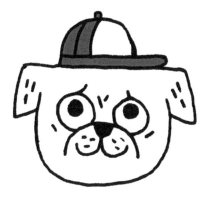

Baseball Cap

Doodle hats on these cute pups.

Turban

Graduation Cap

Fedora

Top Hat

Chef's Hat

Party Hat

Funky Furbaby

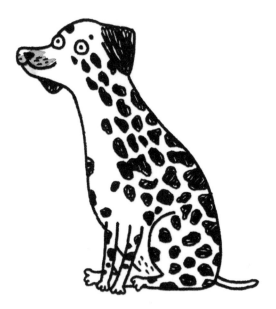

Classic Look

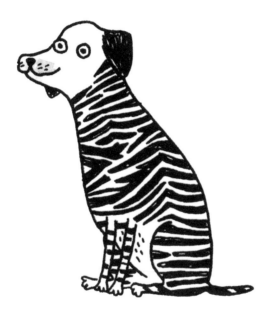

Zebra

Hawaiian

Argyle

Tie-dye

Glitter

Camo

Paisley

Anthropomorphic Dogs

These dogs have been anthropomorphized (that's fancy talk for "attributing human characteristics to animals"). To draw an anthropomorphic dog, just imagine you're drawing a person, but with a dog's head and paws instead of hands!

Becca Boston Terrier Blogger

Walter Whippet the Waiter

Dr. Dinah the Dachshund

Sir Spanky the Spaniel

Lucky the Lab Technician

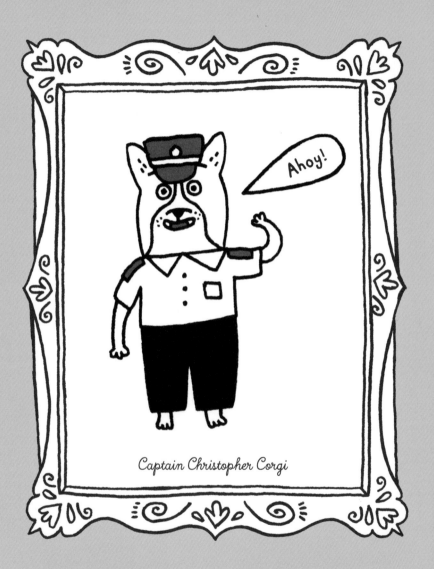

Captain Christopher Corgi

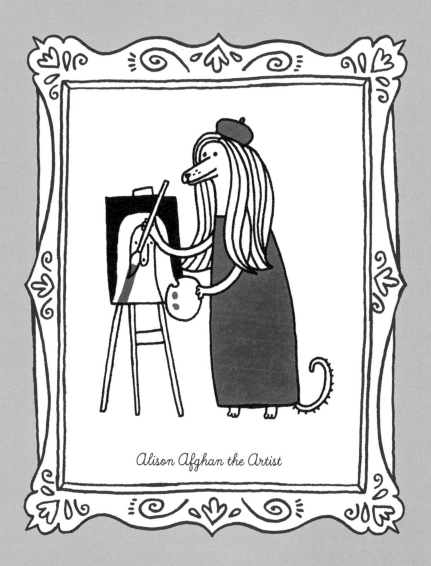

Alison Afghan the Artist

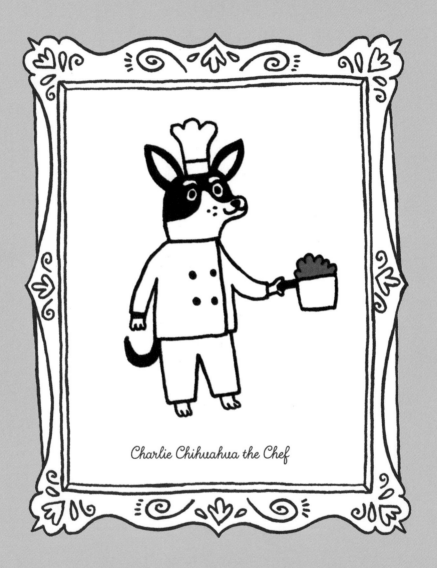

Charlie Chihuahua the Chef

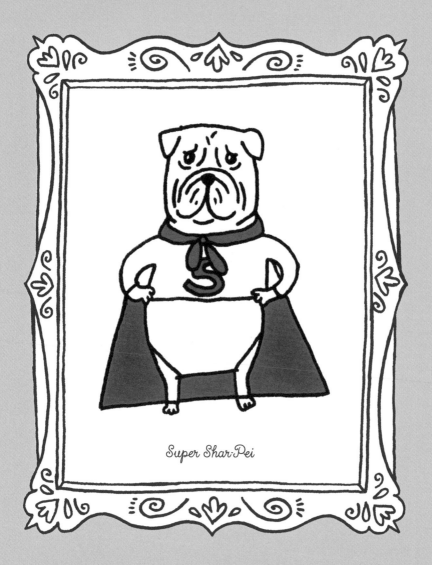

Super Shar-Pei

Wendy the Wolfhound Witch

Lumber Jack Russell

Dogs in Costumes

What does a dog love more than sleeping, walking, and playing combined? Why, dressing up, of course!

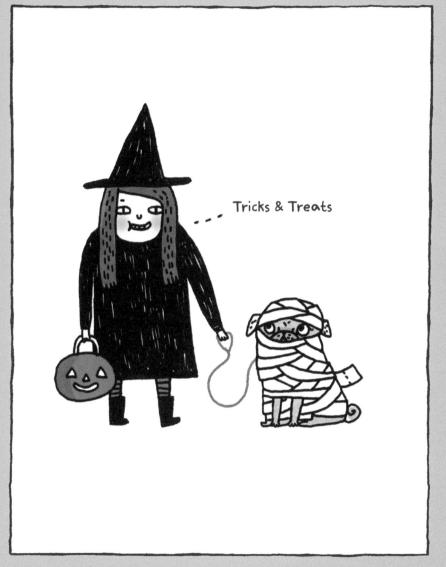

Tricks & Treats

Doggie Digs

Traditional

Classical

Tent

Igloo

Trailer

Postmodern

Playtime!

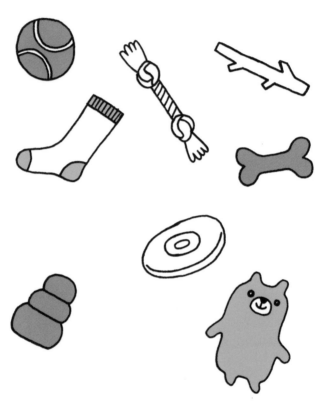

Doodle your doggie's
favorite toys.

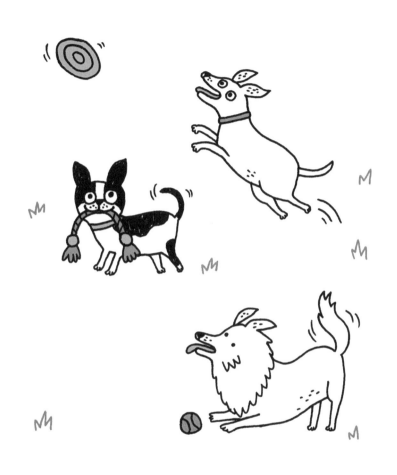

These dogs are having fun playing in the
park. Draw your dog playing too!

Traveling Dogs

These pooches are all ready to go on their travels.
Where do they think they are going?

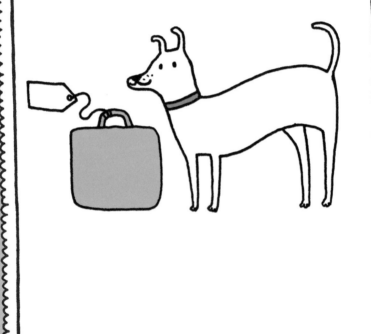

Dogs & Cats

Lovers or haters? You decide!

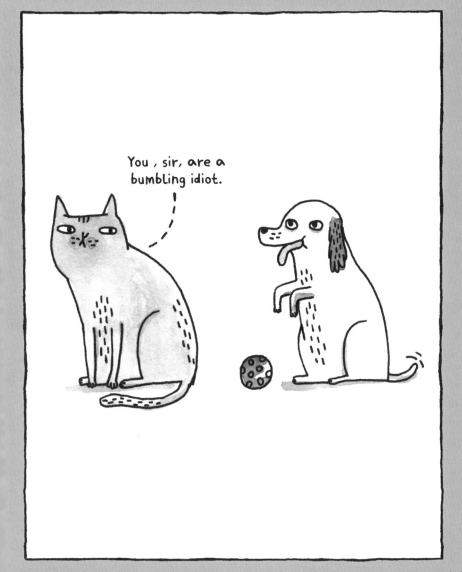

Part 4

DOG
DOODLE
TEMPLATES

Now it's your turn! Doodle some fabulously furtastic designs on these plain pooches. Then doodle in some doggy accessories—bones, food, balls, etc.

DRAW SOME FANCY OUTFITS FOR
THESE SWEET POOCHES.

Make a Doodled Mug

Here's what you'll need:

White
Ceramic
Mug

Pencil
(optional)

Ceramic paint pens or
permanent
markers (any colors)

Wet Wipes

An oven, preset to
350*f / 180*c (optional)

1. Decide what you're going to draw on the mug.

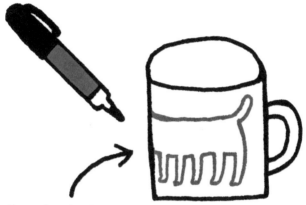

I'm going to draw a
dog with lots of legs
because...well, why not?

2. Draw your design out on paper first.

You can also pencil in the mug if you feel like it.

3. Start drawing your design on the mug.

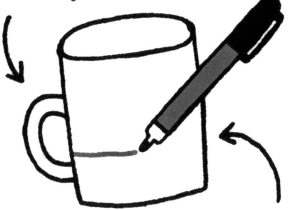

Start on the opposite side of your drawing hand so that you don't smudge your artwork as you go around the mug.

Don't worry if you make a mistake—just wipe it clean with a wet wipe while the ink is still wet. (Make sure it's dry before you continue working)

4. If you used paint pens, you can make your mug dishwasher safe by baking it in the oven for 45 minutes at 350*f / 180*c (or whatever your paint pen packaging tells you to do).

↑

While you wait, eat some cookies. you deserve it.

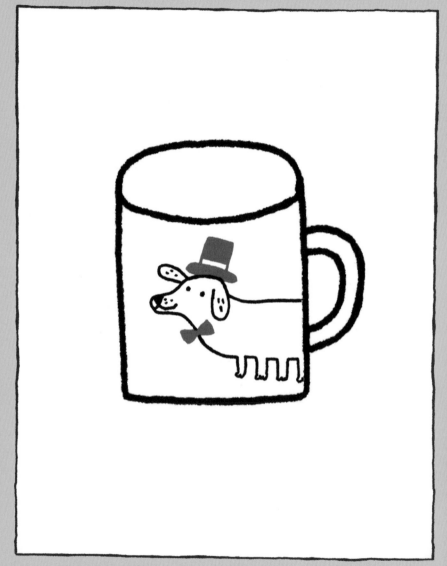

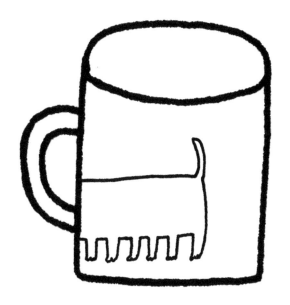

5. Ta da! Let your mug cool, and you're ready to start sipping in style.

About the Illustrator

Gemma Correll is a cartoonist, writer, illustrator, and all-around small person. She is the author of *A Cat's Life*, *A Pug's Guide to Etiquette*, and *It's a Punderful Life*, among others. Her illustration clients include Hallmark, *The New York Times*, Oxford University Press, Knock Knock, Chronicle Books, and *The Observer*. Visit www.gemmacorrell.com to see more of Gemma's work.